Children, Young Adults

Boy Scouts, Young Adults, Sports

Teachers, Students, Education

Family Groups

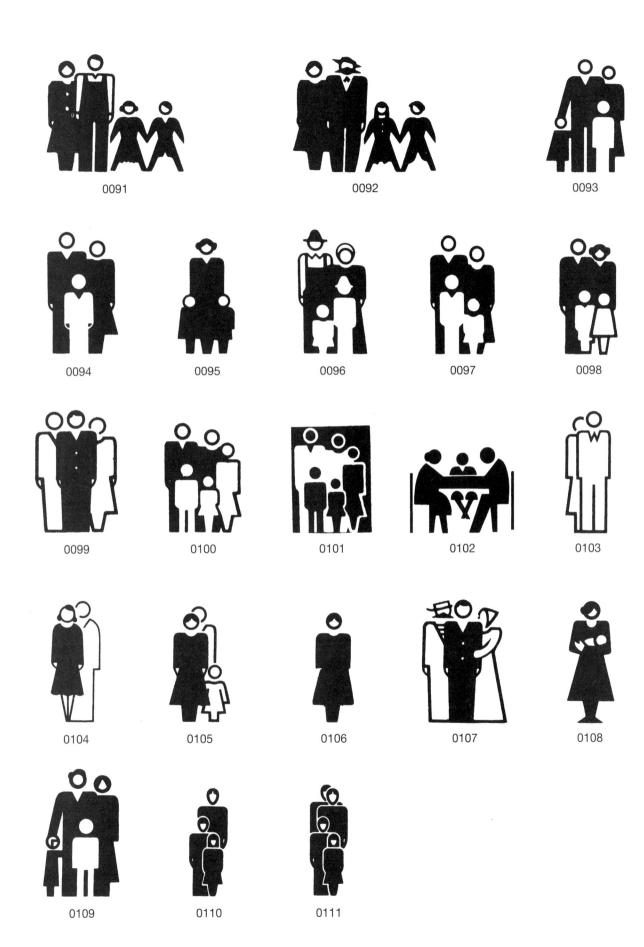

Immigrants & National Historical Types

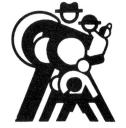

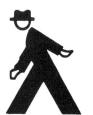

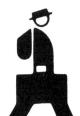

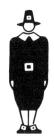

Women

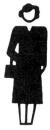

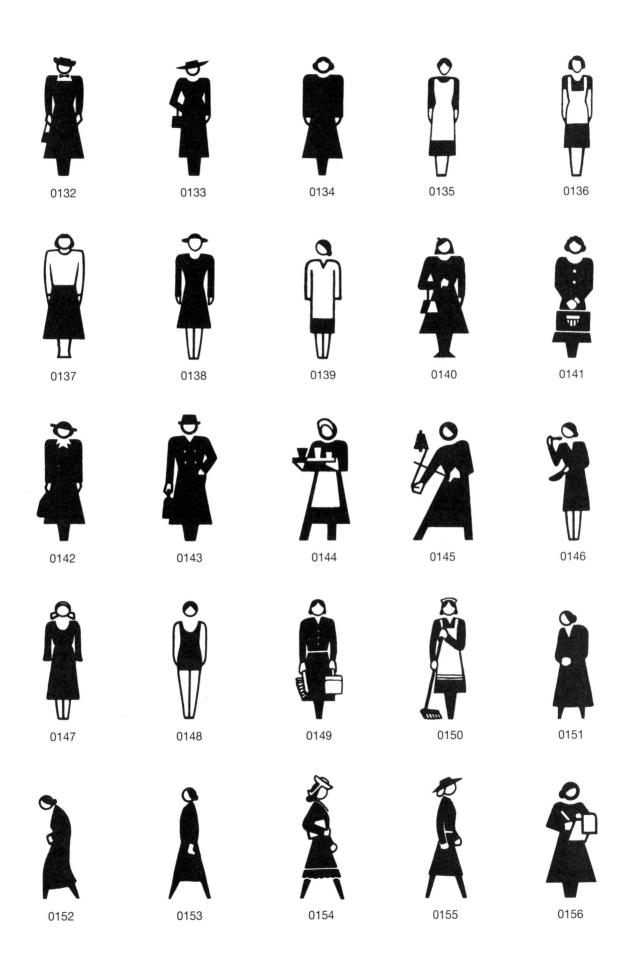

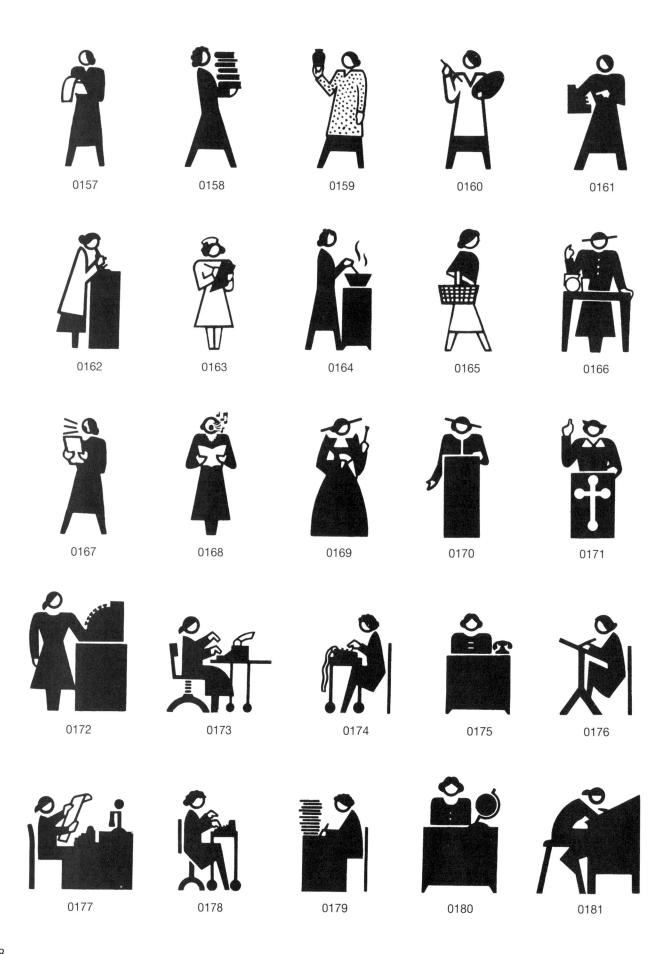

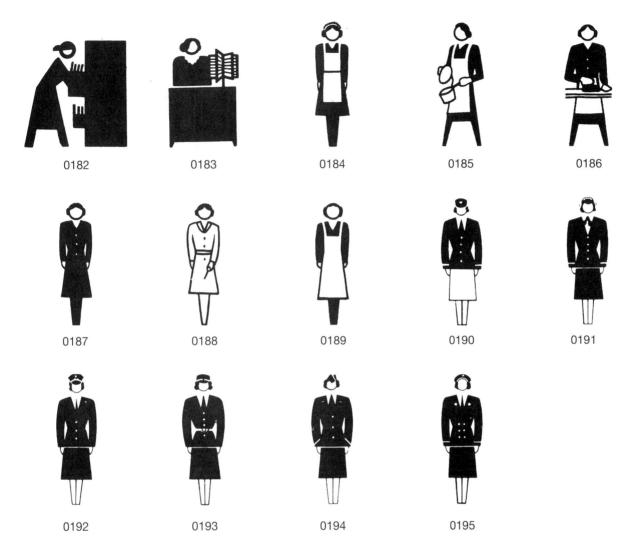

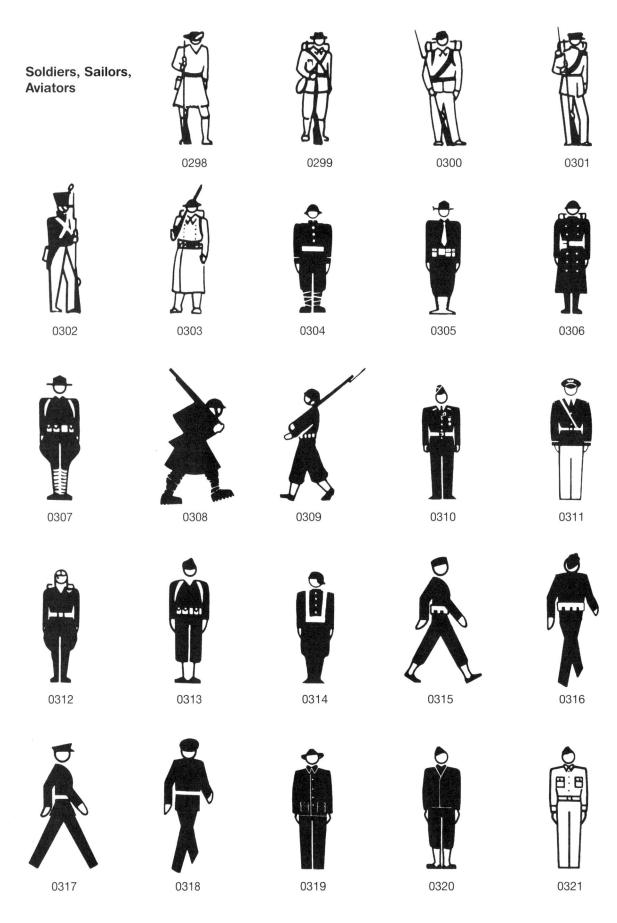

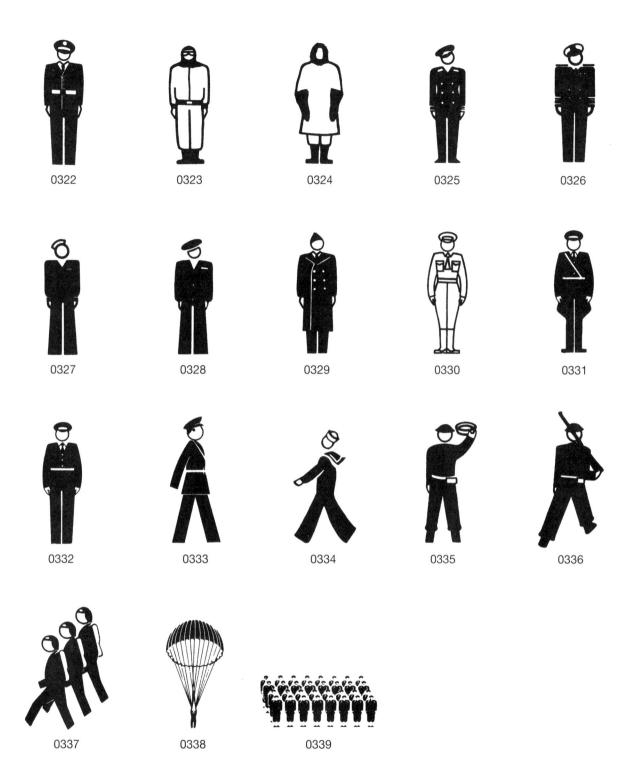

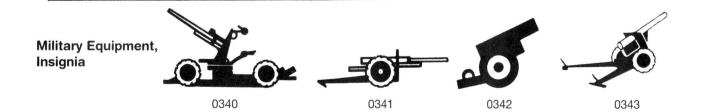

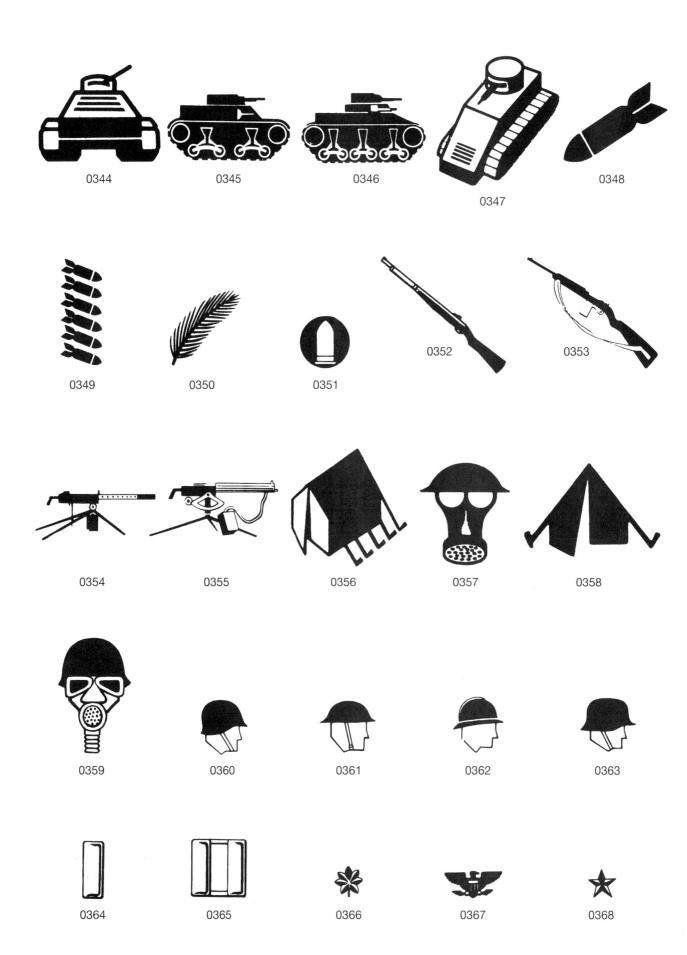

Airplanes

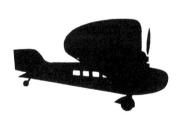

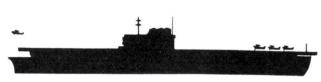

Merchant Vessels

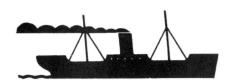

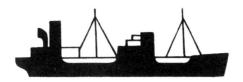

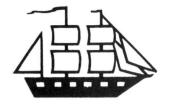

Railroad Trains & Tracks

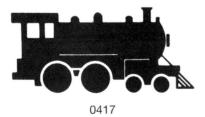

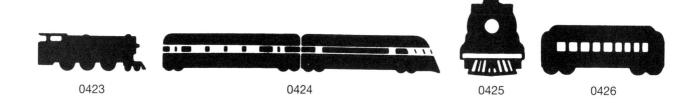

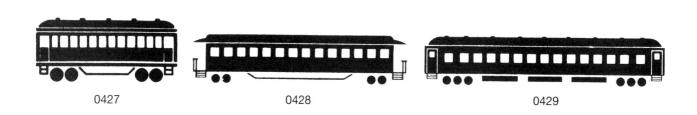

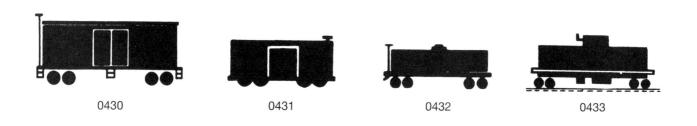

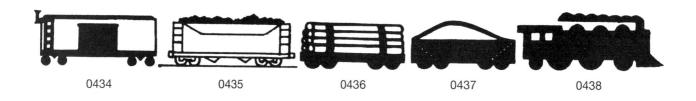

Autos & Other Vehicles

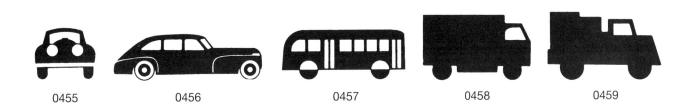

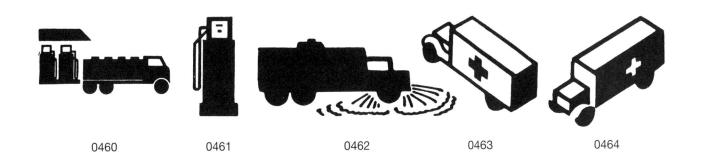

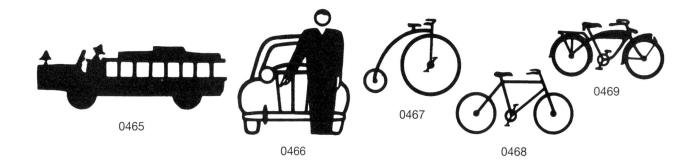

Accidents

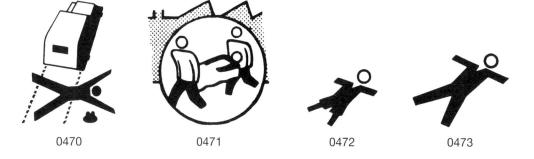

Meetings, Conferences

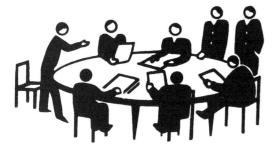

Labor, Strikes

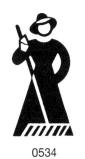

Farm Products, Food, Beverages, Tobacco

Crime

Time, Jewelry & Miscellaneous Symbols

Money, Finance

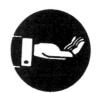

Government & Politics

Government Buildings, Banks & Schools

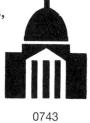

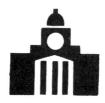

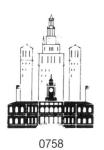

Buildings (General), Houses of Worship, Houses, Stores

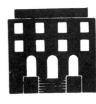

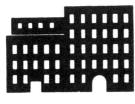

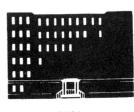

Clothing, Toilet Articles

Household Equipment, Tools, Containers

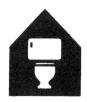

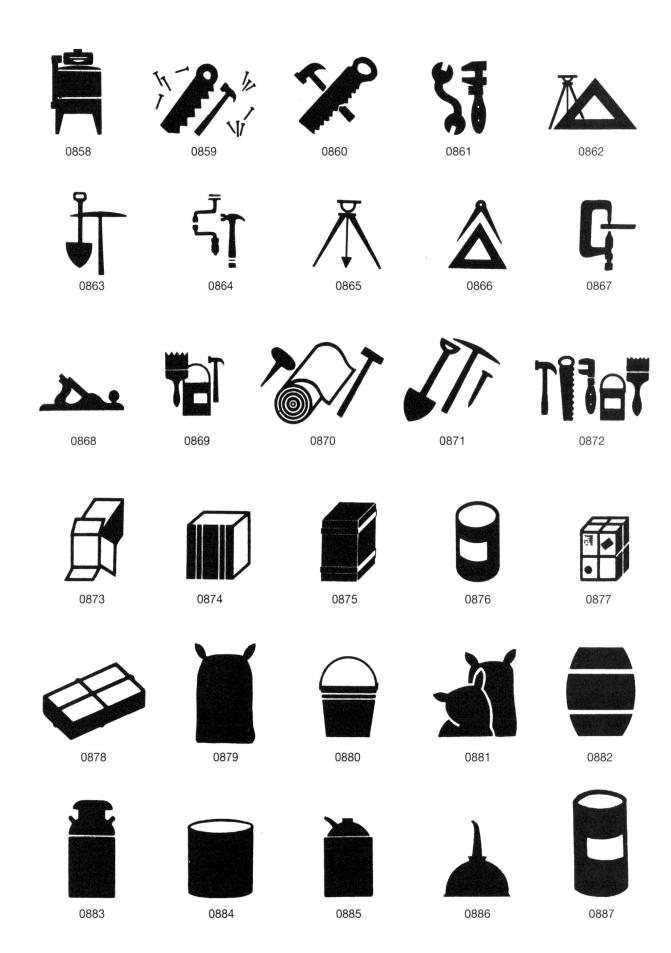

Machinery, Materials, Products, Factories

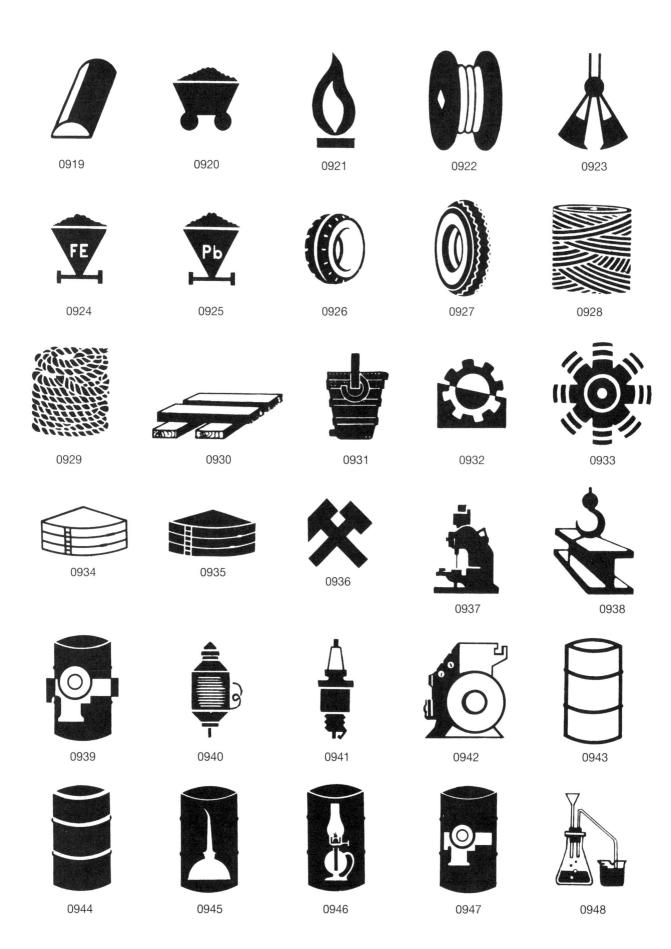

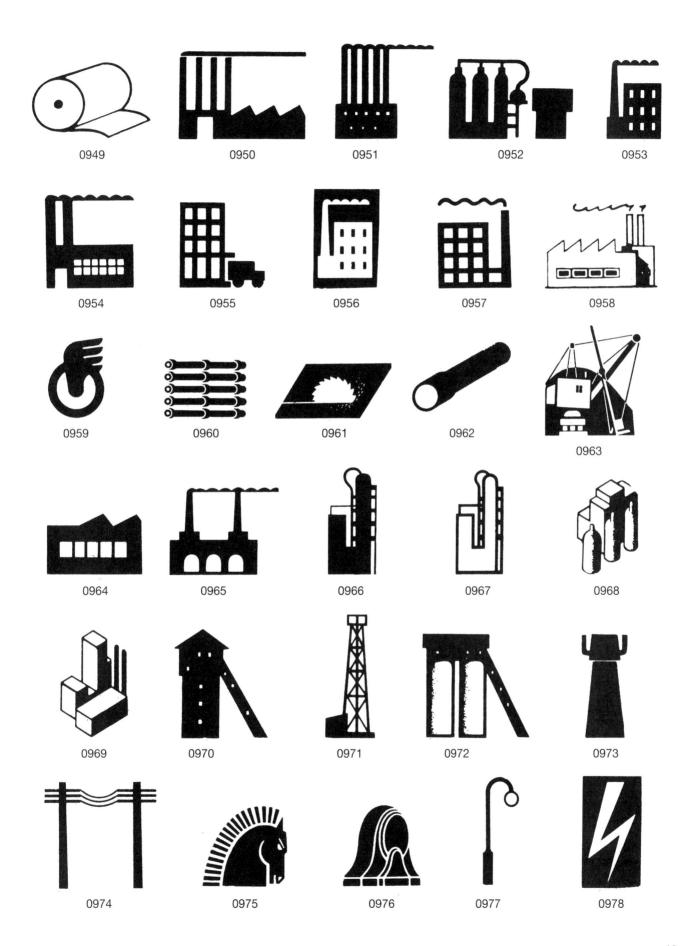

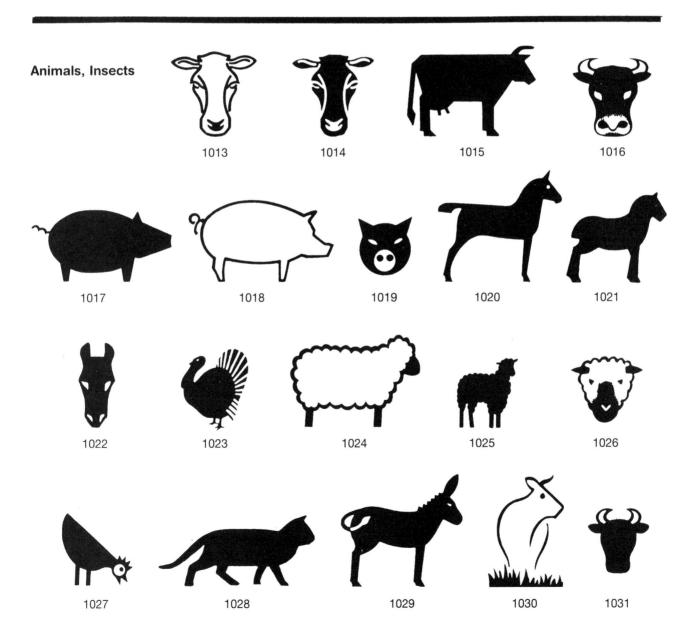

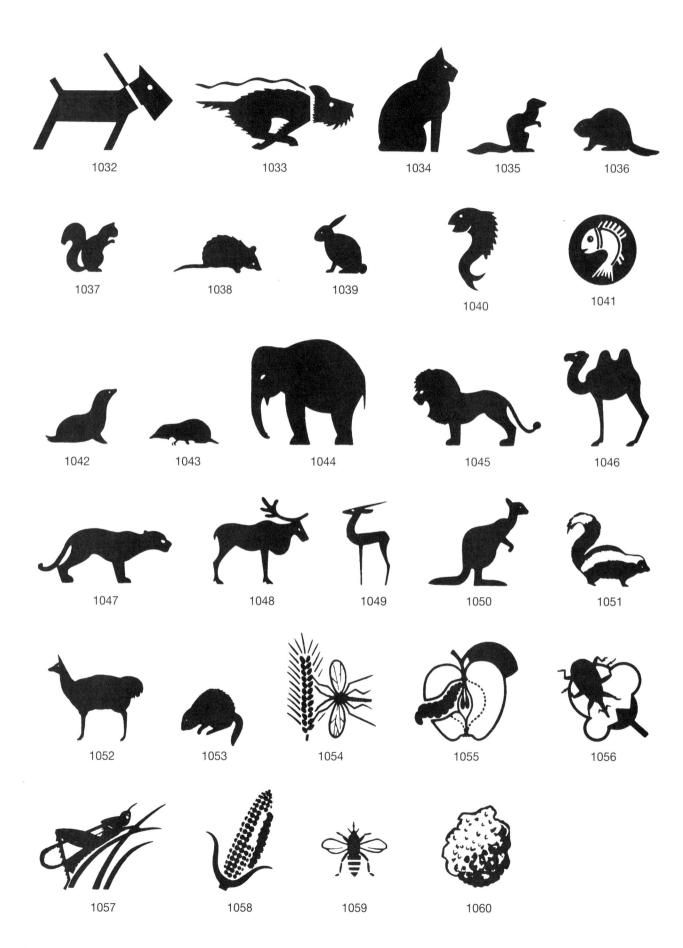

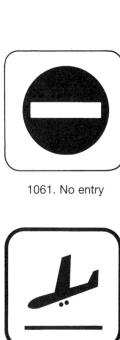

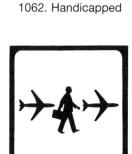

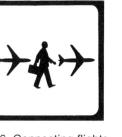

1066. Connecting flights

1067. Subway ground station

1068. Bicycle

1070. Mail

1071. Currency exchange

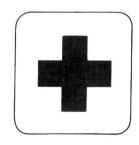

1072. First aid

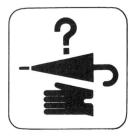

1073. Lost and found

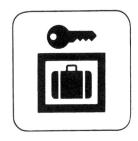

1074. Baggage lockers

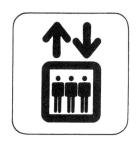

1075. Elevator

1076. Toilets, men

1077. Toilets, women

1078. Toilets

1079. Information

1080. Hotel Information

1081. Taxi

1082. Bus

1083. Ground transportation

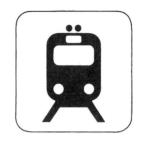

1084. Rail transportation

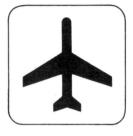

1085. Air transportation

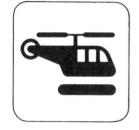

1086. Heliport

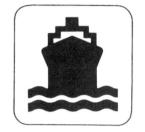

1087. Water transportation

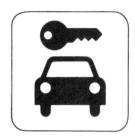

1088. Car rental

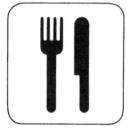

1089. Restaurant

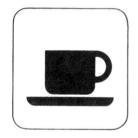

1090. Coffee shop

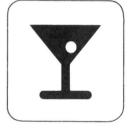

1091. Bar

1092. Shops

1093. Ticket purchase

1094. Baggage check in and claim

1095. Customs

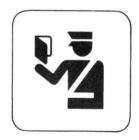

1096. Immigration

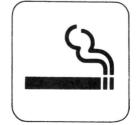

1097. Smoking

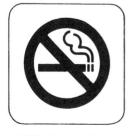

1098. No smoking

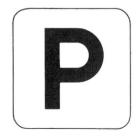

1099. Parking

1100. No parking